STILETTO FEMINISM FOR BEGINNERS

Words By
HELEN COX

Photography By
ANDREW DOUGLAS

Published in the United Kingdom by Helen Cox Books.

Copyright © 2022 by Helen Cox and Andrew Douglas

Paperback ISBN: 9781914238741

Hardback ISBN: 9781914238734

All places and people depicted in the poems in this book are works of fiction. Any resemblance to real people is coincidence only.

For further information, visit helencoxbooks.com or follow @Helenography and @A_Douglas_Photo on Twitter.

More Poetry Volumes by Helen Cox

Water Signs

Where Concrete & Coral Bells Kiss

STILETTO FEMINISM FOR BEGINNERS

Words By
HELEN COX

Photography By
ANDREW DOUGLAS

Content Description

These poems explore adult themes. They contain explicit language, reference to violence and abuse towards women. They also explore less-accepted corners of sexuality, including speakers that subscribe to the BDSM and DDLG lifestyle.

Please consider this content description carefully before choosing to turn the page.

CONTENTS

PHOTOGRAPHER'S MANIFESTO

BY ANDREW DOUGLAS

The male photographer/female subject has, over the years, gained a somewhat 'sleazy' reputation… with good reason, models, both amateur and professional, have been exploited in many ways by 'artists' who abuse their power.

These photographs are the work of an artist: a writer who wanted to explore with more than her words.

These images are, in a way, about power. The power a woman should have to appear to the world in any damned way she chooses without men deriding her for those choices.

These images are for her… and for every woman.

Poet's Manifesto

In the early days I convinced myself I was just listening to too much Lana Del Rey. And these poems were nothing more than an exploration of art and violence and sex and power.

And that had all been done before and wasn't so revolutionary.

And who reads poetry anyway these days, when the minute hand ticks ever backward on women's rights and we're still all told we should smile more?

But writing these poems taught me just how many disguises Misogyny hangs in his wardrobe.

He is a shapeshifter unafraid to manifest as woman.

And I am his Final Girl.

His Laurie Strode.

Each poem, a knitting needle stabbed through his neck.

This book, his public unmasking.

I'm creating
something beautiful.
(My life).

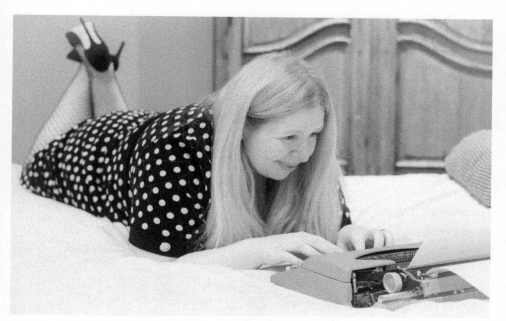

ADMISSION

I am here to seduce you
with all the tenderness I learnt from Gene Kelly.
Let me in, I whisper, and I will paint your fire escape ladders
in every shade of blue. I will write
about the skylight studio in the Village
where Anais Nin printed her esoteric books
(because back then nobody else would)
in words too godless for the dictionary.
I will sing a Soul song about the despondent,
hooded eyes of the Brooklyn Bridge.
If you let me in,
I won't tell anyone
that behind your shimmering
exterior of glass and steel
there is a violent reflection.
That the spire at the top of the Chrysler Building
is made from the same molecules as U-boats.
That the president's father posed
with models in bikinis and hardhats
while they smashed Coney Island's smile to dust.
That in the black-out of 1977 dismembered mannequins
lay comatose along the length of Broadway.
You are a monster (aren't we all?).
I know you cry about it too.
I've felt your rain, thicker than homestead denim.
I won't sentence you to the electric chair for your mistakes.
I know how distorted our vision becomes
when we are treated as nothing
more than territory to be exploited.

Let me in, and I will love you
on the nights when the neon orgasm
of Times Square fills me, makes me shake,
beg, moan for one more carnal hit.
And I will love you on the days
when I don't even have a dime for a slice of pie,
let alone enough to pay the entrance fee at the Guggenheim.
And you don't have to love me back.
You don't have to do anything
but be the wanton saint you are.
The one who looked up Lady Liberty's skirt.
The one who taught Madame Blavatsky all of her spells.
The one who watched Leonard Cohen and Janis Joplin share
a post-coital cigarette. No, you don't have to love me back.
Right now, I don't need love
because like express trains on the subway
I can never get off when I need to
and the map I bought was wrong
and I can't travel with anyone else until I draw a new one.
Right now, I just need you to show me that one day
someone might love me
when I have nothing more to offer than poetry
and a sultry tongue to recite with, the same tongue that will plead
for all the flavours it was never supposed to taste.
I need you to show me someone might love me
at my most depraved, like I love you.

Please, just let me in.

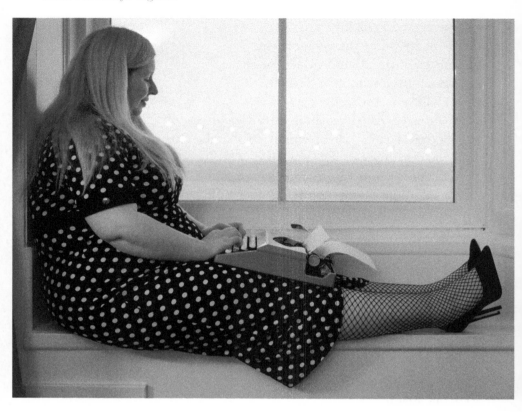

Love is poetry.
Sex is art.

ART HISTORY PROFESSOR

I let him fuck me on his desk; spread my legs
for extra credit beside a framed photograph
of Antioch's Venus de Milo. I liked to imagine
his hair turning whiter with every thrust.
I'd watch the way his glasses steamed up
as his thin fingers squeezed my tits and he taught me
all about his other woman imprisoned in marble.
Memorised lines from his thesis were my erotica;
Venus, our topless voyeur. All the X-rated truths
he told me about her, like:

> the Greeks originally named that statue
> Aphrodite but scholars think she might really
> be Amphitrite, they're not sure of her
> identity but they all agree the curve
> of her waist is the most perfect arc
> they've ever seen, which is perhaps why
> she was once the emblem
> for the American Society of Plastic Surgeons.

In a moment of post-orgasmic clarity
I asked him, *Where are her arms?*
He shrugged. *Nobody knows. But she is revered*
as the most beautiful woman in all of art.
He was still inside me as I thought
about the limbs that would grant her the power
to write her own story, or fight off a rapist or rise
in protest with a home-made banner

she drew using her ironing board as a workbench.
Those appendages were considered surplus to requirement

 carved
 separately;
 an afterthought
 profitless enough
 to be lost –
 yet her breasts
 were preserved
 for centuries.

That was the last time I let him in.
Next semester, when he returned my term paper,
the grade at the top read C minus.

Self-Portrait; Blue Period

I guess I've listened to too many sad-girl tunes
because I've always wanted to be a muse.
To make artists believe they could catch me
in a bell jar like a twinkling, blonde fairy.
To convince critics I'm made of porcelain
shattering beneath the weight of a man
(I never should have married).
Urge spectacled historians to chronicle how I died
posing as Ophelia while oil paints kept me ever alive.
Yes, I believe there is a dangerous power in these fictions,
in being the object of their perverted projections.

I guess I've read too much poetry
because I've always felt mandrakes understood me.
We both drive our friends to frazzled madness
and knock the most sober heads clean off their axis.
We both unblinkingly kill with a spleen-splitting moan
should our heartbroken, Gorgon-haired roots be exposed.
(Baby, please, don't make me turn you to stone).
We are both daughters of deadly nightshade:
poison to the weak; aphrodisiac to the brave.
Yes, I believe there is a dangerous power in the girl
who befriends the most murderous plants in the earth.

I guess I've whispered too many rosemary goodbyes.
The highway's always been my private paradise.
A tarmac twin flame who licks the loneliness off my shoes;
listens to desolate anecdotes about my last ten honeymoons.
A nonstop lover whose kisses taste like the wind and gasoline
who offers neither motel disappointment nor five-star guarantees
(just every secret door between).
I am at peace as the traveller with new horizons in her pocket
who blazes through your Tuesday sky like an effervescent comet.
Because there's a dangerous power in the woman who doesn't belong,
who lives her life crossing through the lines all the rest have drawn.

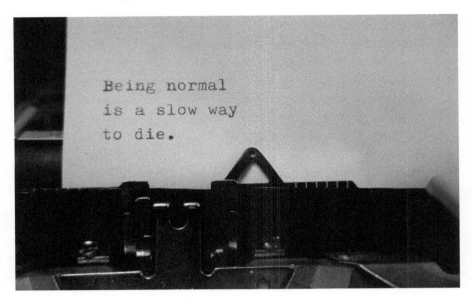

STOP PUSHING ME TO BE GOOD

at directions.
Not everyone
is. And not →
because we failed geography. Or didn't enrol in the Scouts
Not because we are girls. But because some of us don't want to
know why frogs fell from the sky in Serbia in 2005. Understand how
the magician severs a woman in half without breaking her skin. We don't
want to hear the punchline to your joke (which probably
involves nuns or chickens or the Pope). Or to prove lenticular
clouds are not UFOs in disguise. We want to
nurse those darling amphibians back to life
in a shoebox filled with cotton wool. Witness
resurrections. Imagine our own wacky ending
for the pious and the poultry. Believe for one more day that
we are not alone → in the vortex And I, I don't want to
know how the plane engine purrs. I just want to fly. I don't
want to memorize the blueprint to my future → home
thirteen years ahead of time. Don't want to intellectualize
all I grope for → with my hands and my eyes. You see, I
have a broken compass lodged behind my pulmonary valve.

I read
its needle
like a
horoscope.
It predicts →
my white picket fence will be painted Rayleigh scattering blue

Physics Paper Found Folded Beneath the Leg of a Stool in the Ground Floor Laboratory.

1. Title

The effects of resistance towards
high-volume women who dare
to wear Technicolour clothing.

2. INTRODUCTION

Traditionally, high-volume women have been shamed
into wearing dark shades. Simulating uncontainable
dark matter, or a black hole or a shadow that disappears,
as though it was never there, under the hard stare
of the Moon.

Resistance to such individuals expressing
the quantum palette of their identity
has been spearheaded by beauty magazine editors
who assert women with breasts big as twin-Jupiters
and waistlines that might,

at the speed of light, take more than a lifetime
to circumnavigate, should jettison colours and carbs
in favour of spaghettification. These doctrines
were internalised by the general female population
who, in the ladies' toilets,

applied purple lipstick advertised in the magazines
they read, pausing only to recite the practiced lie
to their friends, who had unwittingly asked
for advice on how to dress: black will always be
the new thin, they said.

3. AIM

The aim of the experiment is to test
the real-world implications of resistance
towards high-volume women who dance
with every tone on the spectrum,
as if it were their birth right,
reflecting unfiltered light
into narrow eyes.

4. HYPOTHESIS

The misogynistic policing
of normal female body types
(sometimes by women themselves)
is creating a rainbow shortage.

5. RISK ASSESSMENT

People with a BMI between 18 and 25 may find women who fit
a non-standard model more visible for the duration of this experiment,
and be forced to consider new ideas
such as:

 a. High-volume women deserve to be seen.

 b. It is inappropriate to disguise disgust
 for high-volume women with counterfeit concern
 while issuing unsolicited lifestyle advice torn
 from pages of the very publications
 that have launched a hate campaign
 against such women.

6. METHOD

6a. Materials

- 1 million tears cried by a high-volume woman
 over a period of 40 years
 in which fat-shaming asteroids
 impacted deep in the playground /
 workplace / doctor's office / street.

- 51,881.8 x 1250ml beakers
 (to contain the teardrops).

- 4 decades of accumulated rage
 fuelled by job offers denied
 to the participant
 because she was *fat*
 heated to the surface temperature of the sun
 (6000° Kelvin).

- A plus-size jumpsuit sewn
 of upcycled nylon, harvested
 from a retired hot air balloon.

- A red silk thong
 too big to be sold
 on the high street.

- A gravity-defying
 spray-on bra
 in electric blue
 that won't stab
 into underboob.

- A pair of
 Saturn-yellow
 heels. So high,
 the air thins.

6b. Steps

1. The tears and the anger
 were easily extracted
 from the participant.

2. The two substances were combined
 and a rudimentary rainbow formed
 in a laboratory setting
 to demonstrate that 4 decades lost
 in a void hadn't disintegrated
 every future choice.

3. The participant was encouraged to try
 on the plus-size thong, the sky-high shoes,
 the friction-free bra and the jumpsuit
 that had kissed the stars.

4. Someone outside the laboratory
 shouted in through an open window:
 You shouldn't be flaunting
 such an unhealthy body.
 People might be encouraged to copy.
 We closed the window.

5. The participant was released
 back into their natural habitat.

6c. Diagram

We stare
lovingly through tele-
scopes at the faces of far-off
planets, round as doughnut holes.
Documenting their beauty on official
databases. Yet choose to chide those
globular bodies orbiting closest to our
own. Judging density, needlessly, even
though it is well within the bounds
of possibility they might, by some
measures, be considered
h e a v e n l y .

7. RESULTS

- The participant did not look thin.

- Her smile bore greater resemblance to a rainbow.

- She reported a 94% reduction
 in the number of fucks she gave
 when people asked her
 if she'd tried losing weight
 by eating 57.6g of grapes
 whenever she felt hungry.

- She was told by one passer-by
 (a 92-year-old woman sporting a tangerine hair rinse)
 that she had brightened her day.

8. DISCUSSION

8a. Trends

There was a positive correlation
between wearing vibrant colour combinations
and the realisation that shadows are no place
for any sentient creature to live.

8b. Scientific Explanation

We concluded this was because the participant felt
the colours more accurately represented their authentic self.

8c. Validation

It is better to stand naked
before the looking glass
and smile at the buxom woman
staring back
than to use the eyes of another
as a mirror.

9. CONCLUSION

Earth is being denied rainbows
on a daily basis
due to resistance
towards those women
who eat three square meals a day
and aren't ashamed to take up space.

A Fortune-Teller in New York

A clairvoyant wearing gold hoop earrings begged to read my fortune on 41st Street. I told her, *no thank you* smiling with the conceit of a cat as I walked away. I already knew my fortune:

> I was married.
> I was the dress size all the magazines said I should be.
> I was a writer.

One year later I was walking the same strip and the same flame-haired psychic grabbed my arm. She said she didn't need to read my palm. She could feel my destiny riding towards her like an unsaddled mustang down the August streets of midtown.

She would not be drawn on what my destiny looked like. She would only say that when I met with it, I would be terrified. *But you must say yes* she repeated, over and over, like a shamanic chant. *For it is all the missing pieces of your broken heart returning to you.*

I paid the woman five dollars to leave me alone but I couldn't pay off my intuition. There was only one event that could frighten me in the delirious way the oracle described: meeting *him*.

The man who would bite deep through my sweet, sweet flesh until he hit the peach stone at my core.

"PERVERSE"

I once knew the difference between pleasure and pain
now a kiss and a bruise feel exactly the same.
This honeyed ache is a thousand knots from the norm.
Squeeze all air from my throat; I am reborn.

Now a kiss and a bruise feel exactly the same.
Shackle me to the bed; I'll find my escape.
Squeeze all air from my throat; I am reborn.
My doctor thinks that it's cause for concern.

Shackle me to the bed; I'll find my escape.
Pull my hair, hard; hear my cathartic wail.
My doctor thinks that it's cause for concern.
I need every touch to be tenderly stern.

Pull my hair, hard; hear my cathartic wail.
Cut out the numb tumour my ribs can't contain.
I need every touch to be tenderly stern.
Keep your red roses; give me scarlet rope burn.

Cut out the numb tumour my ribs can't contain.
This honeyed ache is a thousand knots from the norm.
Keep your red roses; give me scarlet rope burn.
I once knew the difference between pleasure and pain.

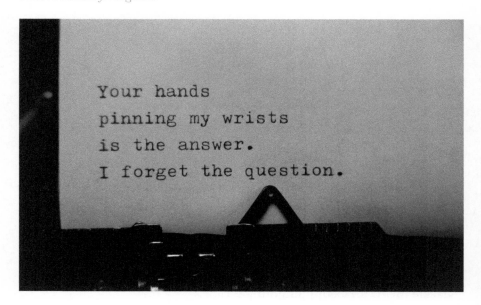

Stiletto Feminism
for Beginners

I'll be your private peep show Daddy,
 in my five-inch heels.
Germaine Greer won't approve of my push-up bra
but that's part of its appeal.

I'll be your private peep show, Daddy,
 and deny those scholars who speculate
that I can't be thrown over your knee for a spanking,
and reserve my rights to equal pay.

So, watch me suck my fingers and imagine I'm your little doll –
a term they'll denounce as degrading,
when they debate it in their lecture halls
while we grind in our private peep show, Daddy;

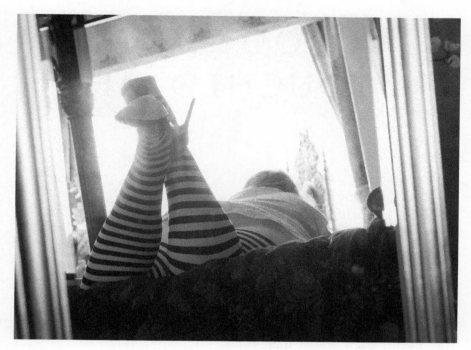

NOBODY'S EVER TOUCHED ME

After Lana Del Rey

without wanting to fuck me.
It's a side-effect of being born
under the magnetic November moon,
and of this shell I built
over four hundred million years,
constructed from the particles
of sand dollars and starfish,
of ancient oceans whose names are now forgotten.
Look at my shell by starlight; it will show you your dreams.
Yes, I believe, it is one of these trifles
that makes even strangers want to unbutton me.
Or, perhaps, it's just the company I keep.
I did, after all, once date Picasso's
great-great-great-grandson
who painted me – his soulless fruit bowl.
Oval melon tummy, pear-cut hips,
breasts: firm apples, tangerine pith lips.
One day, he let me look at the canvases;
they all bled in shades of red.
It was only then I understood
I was nothing
more profound to him
than a craving
for curving peach flesh.
There was not one spatter of cobalt spirit
not one violet thought that hinted
he'd even glimpsed me at my core.

So, I spat him out
and went to dinner

with James Bond's younger brother
who spent all seven courses boasting
about the women he'd seduced:
who – like Russian dolls – disappeared
into one another:
Elizabeth,
Georgia,
Olivia,
before being pocketed,
casually, in his tuxedo jacket.
Their names remembered only
because they were engraved into his ego,
like listings on trophies.
Which rather took the shine off.

So, I left him for college.
There, I befriended that amphibian girl
who was always scissoring
her raven hair at the chin
and always wore red lipstick
and always asked if she could kiss me
until one day I let her
satisfy her curiosity about cryptic, hieroglyphic me.
But our connection was only ever tonsil-deep.
Not because I was in denial
about how divine she would look straddling
my solar plexus.
Tits like a fertility goddess.
Thigh-flesh quivering at the power in my fingertips.
But because I knew
some mischievous imp had knotted
tiny invisible strings around my ankles, just for sport.
So whenever I opened my legs a pair of curtains drew
exposing my heart, pulsing, full.

I knew at twenty-four, at twenty-one, at nineteen,
hell, I knew before the first dinosaur hatched
that I couldn't fuck with my body alone.

That's why I waited lonely millennia
for the man with the X-ray eyes
who would take one look at me and say:
There, there, little scorpion.
Curl up next to me. I want you
for more than the existential thrill
of the sting in your tail.
Or the scarlet poems
your pincers etch down my back.
I want all the softness beneath that exoskeleton.
To solve the mysteries deep in your arachnid heart
no scientist can yet quantify.

My favourite pages
are the ones ~~that~~
where I dared
to cross something out.
(How vulnerable).

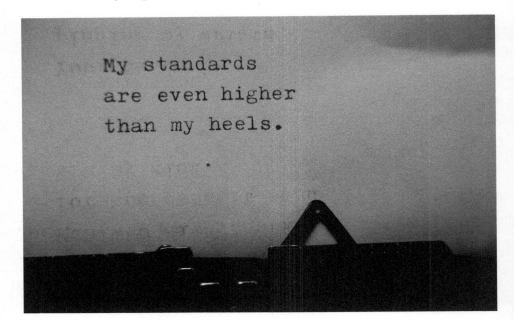

My standards
are even higher
than my heels.

FIELD NOTES: HOW TO WEAR HEELS & AVOID FOOT PAIN

1. Bambi-walk front door to taxi, taxi to restaurant (not very eco-friendly).

2. Contact Dwayne Johnson's agent. Offer to pay for piggybacks.

3. Hitch a ride on the lap of a kind wheelchair-using friend to:
 a. The supermarket
 b. Your son's oboe recital.
 c. Your local, private members sex club.

4. Swap shoes with a man who likes to cross-dress for an hour. Give both your soles a break.

5. Suspend upside down from the ceiling in order to impersonate tarot card number twelve (useful for new perspectives on stagnant situations).

6. Orbit through cloudless blue eternity on a tyre swing in Orange County.

7. Pose on all fours in red lace lingerie waiting for:
 a. A firm spanking.
 b. A strap on.
 c. A hard cock.
 d. An alien probe.

8. Use your degree in engineering. Construct a pair made of marshmallow. Unparalleled comfort and a quick snack on the go.

9. Cartwheel everywhere.

10. Lie on your back. Calves hooked over his shoulders. Toes pointing to Orion.

DRINKING BOURBON WITH YOU

After Frank O'Hara

is even more exciting than my plane touching down in New York,
partly because you once told me
this brand tastes like my voice: warm, rich, husky,
partly because our love is a secret
locked in the Federal Reserve vaults
and sharing a drink, just us two,
your hand on my thigh under the table
is the closest we'll come
to doing what *normal couples* do
and I would rather look at you than the Manhattan skyline at dusk,
or magenta leaves at Corona Park in autumn,
or Pollock's canvases at the Gug,
because the grey cloud of your beard is its own abstract masterpiece
and your cologne smells like horse chestnuts
and your need to worship me is writ across your face in neon
and who needs the East River
when there is the blue grey of your eyes
and who needs the Chrysler reaching for heaven
when your erection is pressing against my hip
and who needs October dew on spider webs
when you have your own wolf to hibernate with
and who needs art
when there is someone in the world aching to rip your clothes off.

BAD MATHS
PROBLEM PART 1

16 passengers sit in a carriage on the Piccadilly Line.
1 of them is me.
2 of them are 12-year-old boys (1 of them is you). 2 x 12 = 24.
Double that figure, by the power of male privilege,
and x = 48 daltons of intimidation.

You've asked the 14-year-old girl sitting opposite you
for her digits 9 times.
Carry over the 48, multiply by 3^2 and y = 482 candelas of coercion.
Halve 14, by the logarithm of systemic sexism,
and xx = 7 units of agency. 482 > 7 (xy > xx).

The first 6 times you asked for her number, she laughed
out a nervous *no*. By the 7th try she noticed your probe
was coming in ever-decreasing integers.
On the 8th, the diameter of her eyes
increased by 97%.

On the 9th attempt, I knew
from the way she awkwardly hugged herself
that there were 3 mathematical constants
dominating the gaslit vertices
in her head:

1. This is her fault for being pretty.
2. If she smiles, they'll give up, eventually.
3. If she laughs, diverts their attention

from the fact that she's rejecting them,
they might not follow her when she gets off the train.

I am 38 + I know what you are doing is wrong +
I'm not afraid to tell you.

38 to the power of understanding how failing
to clarify the rules of consent
to 12-year-old boys leads to the world's worst Fibonacci

(next in sequence:
18-year-old yobs
who don't take no for an answer;
28-year-old men who slip
something in her drink, just to relax her)
= 54,872.

54,872 > 482.
She said no, I call across the carriage without calculating
the probability of you carrying a knife. You spin
180 degrees south + square up to me. Then spit
an open set of irrational expletives that, like π, trail on for infinity.

You need to learn this now,
I say, calm as a cool million,
over your immeasurable vitriol
that only increases in volume.

BAD MATHS
PROBLEM PART 2

+ if I had not been there
that day
could the number of people who spoke out
have been expressed like so:
$n = 0$?

How to Enjoy
Sex After a Failed
Marriage

After Lorrie Moore

Arrange to meet your lover in a cheap motel next door to the restaurant where your husband used to take you. The place where he always cautioned against ordering the lobster, the tablecloths were all virgins and the waiters were trained not to stare down the front of your dress while pouring Cava.

Although your rendezvous is set for lunchtime on a Tuesday, sport a pink tutu to imply you're a playful, care-free spirit who still buys tickets for Disney on Ice, dreams up whimsical backstories for the gingerbread men you eat and never insists on using a condom.

Windmill through the revolving doors like you're an off-brand Julie Andrews. Make eye contact with every person in the elevator, except him. Deliberate whether anyone has figured out you'll be naked less than nine minutes from now. Conclude that only the eighty-year-old with marshmallow hair knows your secret. She once screwed in a cheap motel, forty years ago, she drew with eyeliner down the back of her calves. She didn't smell like hard caramel and lavender then.

Breathe in the jasmine base notes of your perfume and smile like a drunk coyote. You thought you were Lady Godiva. But you're just following in Missis Mallowhair's socksandled footsteps. Still, she doesn't look a day over sixty-nine. A good omen. You'd rather have sex than Botox.

Once inside your rented cocoon, forget about all the night classes you took on How to Undress Like Your Ex-husband Never Rejected You. The guy who taught the programme wore elbow patches non-ironically, how much could he really know about the female orgasm? Forget all the self-help from your Kindle. Forget the banana bread you baked to make peace with your yellowed wedding dress.

The TED talk led by a sex therapist that climaxed with a discount for her latest online course. The documentary you watched on how to give blow jobs like the women of Pornhub. Eternal Sunshine of the Spotless Mind all that fuckery.

Just look into his blue velvet eyes. Just let him squeeze your tits while you confess you always cry at the end of *The Princess Switch* when you watch it on Netflix, and you don't know why. Just let him pin you hard against beige wallpaper, like a work of art, and kiss you until the panting mouth of a new future tears open as effortlessly as your blouse.

PHOTOGRAPH ME, NUDE

my artist / I want / to see / the fullness / my breasts through your eyes / to become / your next / fascination / and / your last / I saw the pictures / you took / of the moon / can you capture / all my phases / the shy / enchantment / of my crescent / smile / my planetary curves / the way I die / in a void / black / opal transmitting / a scream / nobody hears / the price / a woman pays / for daring to walk alone / through the night / only / to rise / again / in headlines / vigils mislabelled as protests / such a pretty / walking corpse / At my peak / I have been called / too intense / are you equipped to create / portraits of a body that climaxes / so violently / it stirs / the oceans / can you illustrate why / all wolves salivate / when they see / my creamy flesh / aglow / can you capture the aloof / satellite / I am / always

 orbiting

 the

 sub-zero

periphery/

Don't / crystalize me / in your lens / my artist / bring me to life / find a way to reach / up / touch me / in places / nobody else ever has / bare / my volcanic scars / convince magazine editors to print them / on the front page / instruct me / to spread / my legs Shoot them like you did / diverging / railway tracks in Norfolk / one line / pointing to the centre / of the Earth / the other /to Jupiter / Yes / those are little diamonds of want / raining / between / my thighs / lick them / taste / heaven just for a millennium or two / document / the way my body arches / as if a sungrazer / trailed / along my spine / kiss / sweat / stardust / nebular fear / from every alien / corner of my universe / Then push / my legs wider / off / their axis / as you take / your close-

up of the organ / academics believe / defines me / as woman / as if / it had nothing to do / with how many heads / I've cradled / the number / of catcalls I've been told / were some big favour / how many minutes a day I think / about your lips pressing / without mercy / against mine / Photograph / me / nude / my artist / I want / to decorate / the world / on my own / terms / to fool / all those discerning critics into thinking / that if they've seen / me / on a clear night / unclothed nipples / hard pink /\ pussy /\ over-exposed / They have seen me naked

MACHO FERN

I cradled
you between
the West Indies
and the frostbitten North. You promised not to leer at my
white roses. Snap up-skirt shots of my foxgloves. Catcall my catkins.
So, I planted you in the shade. Watered you with my tears. Poor little
evergreen. I weep
now imagining
how even when
autumn strips and
gilds your closest
friends. you will
never know the
relief of lowering
those leafy swords
stabbing from
your stem. I
play Vivaldi
for you when
the moon waxes
full, whispering
over the viola
strings: *surrender,*
Dear One. Your
weapons look
too heavy to
carry all
alone.

FIELD NOTES: PAST, PRESENT AND FUTURE IMPLICATIONS OF THE COLOUR BLUE IN A REAL-WORLD SETTING

After Maggie Nelson

1. My eyes are Tiffany boxes.
 (Open them. What's inside?)

2. I can only fall in love with blue-eyed men
 though I am not particular about the shade.
 It's been this way since a boy with reptilian eyes
 broke my heart at seventeen.
 I admit, I sometimes worry it's just another excuse
 to spend life looking for reflections
 of myself in the eyes of lovers I take.
 I am that narcissistic.
 Which explains my fascination with daffodils
 and why I always sit too close
 to the water for my own good.

3. That night, at the pub in Islington,
I wore blue mascara as a covert signal
that I was different from all the other girls
you'd undressed. I batted my eyelashes
transmitting in Morse Code:

I am Alexander the Great's ex-wife
I unearthed the secret to eternal life
in a cemetery in Macedonia.

I inspired Leonardo Da Vinci's first
(but now long lost) painting:
Woman, naked, crying the Arno into existence.

I slept with Samuel Beckett
before Peggy Guggenheim,
and, by the way, she didn't fuck
shiploads of men
because her father died on the Titanic
when she was young.
She just liked cock.

I was the one who suggested to Alf Kinsey
that he should write a report on human sexuality
at a Christmas party in Hoboken.
I was drunk on Martini.
I was joking.
Blue humour, you know?
But not everyone gets me.

I once read an interview with Talullah Bankhead.
I'm actually her love child.
Billie Holiday is my "dad".
In the photograph, Bankhead wore a dress
patterned with peacock feathers.
She told the interviewer: Sex?
I'm bored with sex. What is it after all.

If you go down on a woman
you get a crick in the neck
If you go down on a man
you get lockjaw.
And fucking just gives me claustrophobia.

4. May the record reflect
 I am *not* afflicted
 with claustrophobia.
 Cyanopsia is another matter
 (see note 16 for details).

5. Are violets blue?
 After extensive study I've concluded
 every Valentine's poem ever written
 is based on a fucking lie.

6. My typewriter is built of cheerful turquoise plastic
designed to brighten an office on Lexington Avenue.
Like all tactile objects, it is obsolete.
It wrote headlines the day JFK was shot.
Never forgot the manicured nails of secretaries
who typed memos and scratched blood
down the backs of their married bosses
in the era of free love. I swoon
for the delicate violence of its typebars.
How it thrusts every consonant hard,
kisses each tender vowel onto the page.

Oh, to meet a man who fucks like that.

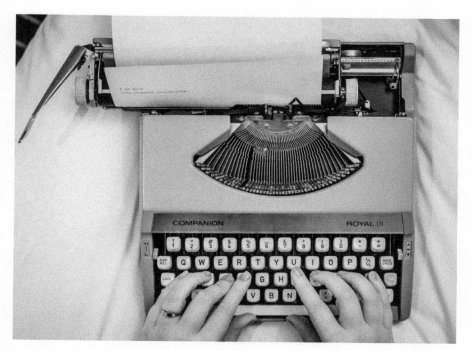

7. Lover, next time you're in New York,
 buy me a little blue box, won't you?
 Tie my wrists with the pearls snaked inside.
 Bind my ankles with the white ribbon.
 Then, Mr Silhouette with eyes like the Irish Sea,
 make me your sex toy.

8. Once a boy, who smelled like macaroni cheese,
 called me a blue stocking.
 Since the slur fit me so well,
 like any intellectual,
 I began to experiment.
 Hours I sat in the public library,
 pretending to read a well-thumbed copy
 of Mother Teresa's biography,
 a vibrator stuffed down the front
 of my white cotton panties.
 The words *good girl* embroidered
 just above the crotch; thighs shaking
 with seismic orgasms.
 Mac and cheese was right.
 This *was* where I belonged.

9. The blueprint to my birth chart
 was leaked to the media in 2014
 by one of my ex-boyfriends.
 Nobody really covered it
 because that was the year
 J-Law's phone was hacked for nudes,
 though commentators at *The Times* concluded
 what happened to me
 was, in some ways, much more revealing.

10. At a guess, I imagine my ex
 was hoping people would notice
 my Mars was in Scorpio.
 From there, he no doubt expected
 the masses to calculate
 how many blow jobs I've given,
 the specific methods I use for masturbation,
 and the precise coordinates at which
 I've received oral sex in public.

11. He sent me a text:

 Now everyone will know
 what a disgusting whore you are.
 People will shout slut at you in the street.

 a. He didn't think my oral fixation was disgusting
 when I was on my knees.

 b. Being called a slut turns me on.
 Worst. Revenge. Ever.

12. Last year, I went to my doctor
 with a case of Cyanopsia
 (that's what the white coats
 call it when everything you see is blue).
 He prescribed Prozac of all things.

13. I explained I considered seeing the world in blue a gift
 and wasn't trying to cure the affliction.
 On the contrary, I was hoping he could recommend
 something to enhance the symptoms.
 Like flashing my tits at the man I love
 on a hotel balcony in Florence, in the rain.
 He said he couldn't in good conscience advise that.

14. I stared at his tie
 which looked like a strip torn
 from the Russian flag
 and wondered how long it had been
 since he fucked his wife.

15. My ex-husband once asked me
to cuddle a teddy bear
while I sucked his cock.
I enjoyed the experience
more than I thought I would
and the bear has been a loyal friend
throughout our divorce.

16. I left because
after the honeymoon
every night I came home from work
I found him
slouching on the couch
in the same powder blue shirt
with his fly unzipped.

17. He never offered me sex
or even a good fingering.
Which I thought particularly rude
given that the only attire I wore anywhere
was a pair of scarlet heels.
And a pair of fishnet stockings
in the winter.

18. He never once suggested
 watching a blue movie together.
 I had some classics in my collection.
 Bondage.
 Gangbangs.
 Lesbian gangbangs.
 Bondage lesbian gangbangs.
 And a heart-warming tale
 about a young girl who hails a taxi
 to get to college and winds up letting the driver
 fuck her in every hole at a rest stop
 halfway to Harvard.
 When I shoved
 the tapes into the VCR
 he pretended
 to fall asleep.

19. Since the divorce,
 I can't write
 in sapphire ink anymore.
 Only in raven.
 The tarot cards warn
 this means I am
 in a dark place.

20. I told my analyst about the malady.
 She grows lilies of the Nile
 on her windowsill.

21. I like to watch
 their blue asphyxiated heads
 bow in the breeze from the open window
 with more reverence
 than I ever learned.

22. I explained that I've laid
 down a new rug in this dark place.
 Now it feels like home.
 More than that.
 I've learned I prefer the dark.
 The navy.
 The Indigo.
 The edge of space.

23. I find having my nipples licked
 while blindfolded
 generates far more electricity
 than those tiny shrugs of eroticism
 endured when I could see
 the people I was sleeping with.

24. Midnight blue is the colour
 of good quality sleep.
 I discovered this while dating a man
 eleven years my senior.

25. Inspired by his love for me,
 he painted the bedroom
 the shade of an evening sky
 filled with too many stars.

26. He said I was the light;
 all I could see was blank oblivion.

27. I now live between two lonely,
 frost blue rivers.
 Right where their mouths open,
 wide and brazen, to the salty North Sea.
 God, grant me the strength
 to be that hedonistic.

28. At thirty-five,
 I dyed
 my hair electric blue.

29. At forty,
 I got my first tattoo
 but still eschewed blue ink.

30. At fifty, I will time travel
 to the 1939 New York World's Fair
 and patent a serum,
 aquamarine in hue,
 that forces politicians
 to tell the truth.

31. Sadly, I will lose
 the formula in an avalanche
 of discarded bibles
 in November 1963.

32. At sixty, I'll discover
 the final resting place of Amelia Earheart
 (an underwater cave off the coast of Bermuda).
 The newspapers will say I'm a fraud.
 Even in the future,
 they never give the truths women speak
 due credit.

33. At seventy, I'll become the first aeronautical feminist to fly to Neptune and collect her own blue diamonds.

34. I'll then conduct several experiments in a laboratory in Greenwich, proving:

 a. Diamonds are not forever.

 b. Diamonds are not a girl's best friend (that accolade goes to the humble, but versatile, cucumber).

35. At ninety-nine, I will die
 in New Mexico.
 My last words will be:
 True love is slippery
 like a frog in your hands,
 ever poised to leap unless
 you keep your grip watertight.

THERE IS WAR AGAIN IN EUROPE

so press your lips against the ink of my new tattoos at Port Olímpic while dusk paints wild carmine clouds / spin me lift me history's heaviest ballerina in Vatican City until they say we are art / unhook my bra on a balcony in Montmartre / commandeer a microphone explain calmly over the radio in perfect diction that this is the end of the world / while you have the whole planet's attention compare my thighs and all that lies between them to the valley of Eden / commission airplanes to skywrite in chemtrails *her poems are all about D* / sneak with me into the bedrooms of fascists whisper in their ears while they sleep that the Danube, silver artery; Roman god will always win in a pissing contest because he connects what they seek to /

divide

but do it all today / this instant precious man / while our nuclear sun is the only bomb burning up the steel blue sky /

A Spaceograph Transmission to the Nurse Conducting My Smear Test

You'll already be wearing your Martian-green
gloves and have sterilised the probe
when I disclose this is not routine for me.
That when you penetrate my cervix,
with apparatus designed by a racist,
one hundred and eighty aeons ago,
I'll feel my ex's impervium penis
and remember I was too polite to tell him:
no. He was a nice guy, you see? Too nice
to go down on me. Or talk dirty enough
to make me wet before we wormholed
on my sofa-bed. Too nice to notice
the stars in me dim. And I didn't want
to shrink-ray his pleasure. And I wanted him
to like me. And I wanted him
to rake autumn leaves in our future garden.
That's why I never told him to stop.
But he left scars no space-age doc could heal.
Every professional with a medical degree
assessed me under unforgiving lights;
flying saucer bright, with mirrors
and spatulas and unlubricated fingers.
And after they'd run a whole starfleet

of tests, and after I had no dignity left,
they showed me a series of graphs
to prove the pain was all in my head.
So, do you have a smaller speculum?
One fit for an Uhura action figure?
Or an ant-woman? Or a midi-chlorian?
An invasion too microscopic to observe.
So I am not reminded of that nice guy
leaving. Or that our future garden died
in the womb. Or that my doctor
with three heads, and not one eye
between them, published an academic paper
leading with the claim
that when it came to Earth girls, like me,
unexplained pain was only science-fiction.

GEOLOGICAL
INHERITANCE:
ABSTRACT

Dolomites in Mexico / remember / the Chicxulub impactor / the green / eyes of every last brontosaurus that laid / down / died in the aftershock / Aren't we material / Don't I hold / minerals / in my bones / Might my molecules / recollect / how fast / acid eats / through / MaxFactor compact powder / tissue / tearing through a back-street / abortion / searing / at the stake / guilty / of nothing / owning breasts / being / magic / Epigeneticists report / the thirteenth generation still / bears / a thumbprint made / three hundred years / before / What if / that thirteenth generation / bequeath / their fear / to thirteen generations / more / What if 65 million years / from / now / a little girl / still remembers / an unwanted / hand / on a knee / a great / great grandmother / murdered / in an alley buried / in shallow dirt / because / she was wearing / a mini skirt / A strip / search / without / probable cause / If everything we did / mattered / if / everything we did / was matter / if every pebble / you threw / into the amniotic / lake rippled violently / for millennia would you / treat your sisters / your daughters / your girlfriends / differently? / One thousand sedimentary / rocks / were surveyed / in this study Initial findings / confirm / the land understands / the long-term / consequences / of rape / far / better than we / We call her / mother Earth / Is that why / we have taken / more / than her hips and her / heart / can bear /

A witch
is just a princess
who has awoken
to her true power.

DAP Notes from Nemesis Adrasteia, Session #1

Data

Nemesis presented with just one wing poking out the back of her navy blazer. Goose feathers sprouting from her right shoulder had been hacked away at the stump. A breast pump trailed from her nipple. Left from when she last fed Helen, and a whole island full of babies. In terms of risk, the patient disclosed they are more likely to harm others, particularly those who have fallen in love with their own reflections and persons who murder innocent, young shepherds. Which seemed oddly specific.

During this first session, Nemesis appeared agitated. The scales on her cheeks burned red. Her eyes, yellow, jaundiced. She reported she had been denied a pay rise in her position at the Department of Justice where she works as the only female magistrate. She learned, just this week, that all her male colleagues earned a higher hourly rate.

Assessment

The patient harbours some unusual fixations, likely caused by the residual trauma of transforming into a fish to swim away from her abusive father. Nemesis has a keen interest in balance and any manipulation of fair license carries the capacity to spark a crisis. Though enraged by the double standards of our society, Nemesis was able to discuss the matter with sobriety. She relayed, with impressive detachment, the whispers

she'd overheard when she asked her manager for a stipend equal to what men receive for spilling the same rivers of sweat.

Psycho, bitch, witch, her coworkers had chanted under their breath, while photocopying yet another workplace harassment case that had just landed on their desks.

Plan

In this instance, I have decided against a prescription of Zoloft. Or sedating Nemesis with Diazepam. Instead, the patient has agreed to thrust her measuring rod up to the stars, shattering the glass ceiling Zeus has danced upon for the last three thousand years. To carve stone tablets with the following words: *if a man can be a father and a CEO without his salary entering retrograde, a mother should be able to accomplish just the same.*

We've arranged to meet again next Tuesday.

Interview with a Female Astronaut, 3000 AD

1. What make-up will you take up into the beyond?

A PhD in Astrophysics
and a comb.

2. Will you cry if any of the hardware malfunctions?

Why? Do you cry
when your hardware
malfunctions?

3. Can you wear knickers under your spacesuit?

Can I? *Yes.*
Do I? *No.*
I like to be all set
for spontaneous anti-gravity sex
with passing alien creatures
who might be fitted with more than one penis.

4. Have you been on a special diet in preparation for your mission?

Yes. I've devoured
the operational manual
for the SS Second Sex,

and the Earth diaries
of Dorothy Vaughan.

5. How will you care for your hair, up there?

I will grow
trichomes on my legs
like a rose.
I will grow
tendrils of coral
from my scalp.
I will grow
fields of wheat
in my armpits
and a forest
between my thighs
in honour
of our mother Earth
I will grow.
I will grow.
I will let myself grow.

6. How will you manage your menses in space?

I'll take the same pill your
great, great, great, great, great
grandmother took
when your great, great, great, great, great
grandfather wanted to fuck without a condom.
Also, retrograde menstrual flow
is space-bullshit.

7. How will you make time for children?

I will
wave at them
from the porthole
at lift-off
until they are embryonic dots
in another woman's womb.

DOMINANCE

You are older than me and wiser than time.
You fuck me like I'm Marilyn Monroe.
You let me pet your long, grey hair like I once did the family dog.
You wash and brush and braid my locks like your 5th daughter, yet unborn.
You hang on my words like I'm your 7th Grade English teacher with the good tits.
You handle me like the warm gun you use to shoot white tails through the heart.
You pledge me more allegiance than the flag; clamping
stars to my nipples, lashing thirteen stripes across my ass.

You are the distant king who seeks to conquer me.
You wait like a nor-easter hurricane on the silver horizon.
You wait for the day when I realise all the castle walls I've ever built
are, in the end, still nothing more than sand.
You know, when that day comes, I will lay down with the crab shells;
let the tide wash me, and my empire, away.

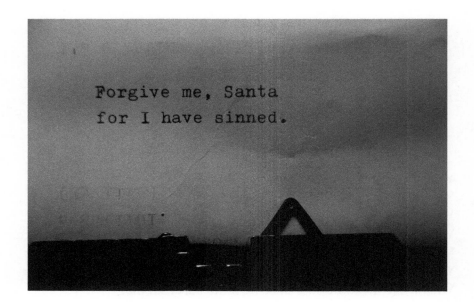

C.S. LEWIS TOLD ME I SHOULD

> *"She's interested in nothing now-a-days except nylons, lipsticks and invitations."* —
> *The Last Battle by C.S. Lewis*

be a good girl for Santa. Abstain
from sheer nylons,
and Eve's apple-red lipstick;
to never lie
bared and shaved and bound and "shamed"
on the Stone Table while all gods and devils watch,
and stroke their voyeuristic cocks.
A pair of seamed stockings
that have lain unopened too long
in a box at the bottom of my wardrobe
turn to virginal marble.
A bad omen that the dry pond once hidden
by my hymen
has frozen over.
A warning not to kiss any more nice boys
who'll only fuck after we've both showered, separately.
I've never liked Turkish Delight
but my cunt throbs for all else I crave,
protesting: *it's always winter here, never Christmas.*
I *need* spring to come.
To witness violets violently orgasm.
Taste the mauve petal of his tongue;
for my yellow-stamened name to fill his mouth.

Keep your promised thrones at Cair Paravel.
I want to sit on his beard this instant
ride his face
a shield-maiden mounting her horse, storming into battle.
Fighting for the same right men have savoured for centuries:
to do what the fuck they want
with their own bodies, and call it godly.
I want to start saying *yes* to party invitations
flirt hard enough to solicit the weight
of another body on top of mine after midnight.
To announce on the evening news that I am nobody's fucking rib
but a whole person for whom want is its own universe,
ever ex p a n d i n g. I want to linger just beyond
that lamp-post, wearing nothing but a fur coat.
Wait for a half-beast. Lick bourbon off his lips.
Follow him to his hovel, watch him play with his flute
and return from the experience unmurdered,
in fact more alive.
All the while defiantly believing
that Santa, jellied by his legendary appetite,
is just as fond, perhaps even fonder,
of the "bad girls" who straddle his lap.

ALL THOSE OTHER BOYS SAID I LOVE YOU

picking the three
most common words
they had to hand.

I once murdered
daisies that way,
weaving them into chains,

before crowning myself
a princess
on the shores of the Irish Sea.

It is only now
that I sit
on my rightful throne,

stockinged legs straddling your lap,
staring into your seascape eyes,
my king,

I realise *I love yous*
are much like that petaled round
of death

I once wore
with such green pride
upon my busy head.

I love yous wilt
and turn my stomach
like semolina or cloying pipe smoke

or sleeping
on an unseized opportunity
for a violently tender fuck.

A pea
I felt
through twenty feather mattresses.

Say it often
and idly
enough

and *I love you*
becomes no more
inventive

than a playground chant
you can't quite remember
the meaning of.

But you
are not
a boy.

You have hair
on your chin
and on your chest

obsidian mistakes
glistening
in your past.

And I think you might be
at least half-beast
because of the way you growl,

My
baby
girl.

Those three little words,
rare
as slender stonewort

make me want
to forge
a new crown

spun
from your
forehead kisses.

You moan
that silken
little phrase

knowing
my
weakness

for possessive pronouns;
that I'm a slave
to pet names.

And you slide your fingers
inside me,
smiling, as you feel

the tides of the ocean
I once sat beside
now surging between my thighs.

There is relief
in letting someone touch you
that deeply.

Because, when you call me
your baby girl,
I know you understand

that my heart is stuck
together
with Krazy Glue

and scattered
with glitter, and unicorn stickers
to distract

from the fractures born
of all those unhappily ever afters.
How I cried

once
the bedroom light
went out.

And there is no aphrodisiac
more potent,
no more soothing balm

than
being
seen

for who you really are
behind the blonde hair
and the big tits

and the eye-liner flicks
you hope
disguise

your four-and-twenty
blackbirds'
feet.

That's why I'd rather hear
the magic words,
baby girl, you are mine,

than a clockwork
I love you,
any time.

NOT THE
BLAME GAME

After Simon Armitage

His face was a legitimate warrant card
and his bald head was a burial mound
and his nose was a ducking stool
and his eyes were two capsules of GHB
and his wink was a curfew just for the women
and his wrinkles were headlines asking why she walked home alone
and his ears were one-way TETRA radios.
His mouth was a brown suitcase with a body inside
and his tongue was the punchline to a joke about rape
and his saliva was an unattended drink
and his smile was a false arrest
and his teeth were door keys brandished in a fist.
His collarbone was a blade from Pistorius's gym bag
and his nipples were bullets shot through a bathroom door
and his armpits were shallow graves
and his fingers were the dicks of flashers everyone said were harmless
and his bellybutton was a black eye disguised with compact powder
and his pubic hair was a revenge of acid burns
and his ass cheeks were the pixelated faces of murderers
and his tibias were the lancets she used to self-test for HIV
and his toes were all the excuses for not prosecuting her stalker.
His blue rosette was one of Phil Spector's Grammys
and his pinstripes were lines on a doctored police report
and his voice was a patrol belt wrapped around her throat
and his laugh was a vigil candle blown out

and his walk was a bus that doesn't stop when you flag it down.
She was a ghost transmitting from the white cliffs
desperate to be heard through the static

and he graffitied:

NOT ALL MEN

across her gravestone in neon.

Quiet Reading at Ms Swift's Desk

I planned a grand
subterfuge. Tom Sawyer had
nothing on me. I'd
flick the pages w i t h o u t
digesting a single g r a p h e m e .
Instead I would daydream about
joining She-ra on her quest to defeat
evil Hordak. I never guessed Ms Swift
was well-acqua- inted with such craven
deception. Having taught reception for twenty-
five years. *Finished!* I twittered after far too
few minutes. *Have you?* Ms Swift replied in a tone
I had learned not to trust. She flipped three pages
back and asked: *what's that* *word then?* Thirty years
on, I still couldn't tell you the word she pointed at. If
we hit such blockades in the text we were supposed
to stop. Look it up. After a full minute of sub- zero
silence, she said: *I think you* *had better start again.* With
a nod I did as I was told. Even tho- ugh Roger
Red Hat was a stone cold bore when w compared
to She-ra. I wish my teacher had told me then why
she took such pains. That reading was its own
superpower That if I didn't master the tales of
Roger Red Hat I'd never know why the
caged bird sings. Or which way
to vote in an election. O r

make sense of headlines
about a fifteen-year-old girl
from Hackney, strip-searched
by three coppers at school during
her period because she was black.

Strike that. Despite the privilege of education, and
ivory skin, Child Q, I'll never make sense of what
happened to you. Of a girl, bleeding, just as I do,
bent over a school desk by three police officers,
jeering in their invisible white hats.

CHASTITY QUIZ

After Regi Claire

When questioned about my sexual experience I:

A) Always tell the truth.
B) Lie, brag about my duplicity on my blog.
C) Consult the latest issue of Cosmopolitan before committing
to an answer.

At the age of forty I have had sex with:

A) Three men.
B) Seven men and one woman.
C) Ninety-seven men and sixteen women.
D) Could you be more specific about what counts as sex?

The first man I ever slept with:

A) Was an artist, because aren't they all at eighteen?
B) Had three identical triplet heads. One of which always told the
truth. One of which always lied. One of which refereed the other two.
C) Designed an alternative to excel spreadsheets that never quite took
off. It exists now only as a footnote in two computing textbooks. The
titles of said books are: *Between the Sheets: Sexier Surrogates to the Microsoft
Machine* and *Big Tech Bungles: The Billionaires that Never Were*.

The worst man I never slept with:

A) Invited me to a club in Leicester Square the night my grandfather died.
B) Drove me to the Hollywood Hills in his dad's pickup truck to make-out under the stars.
C) Bought me a flight to Paris and met me at a cafe, just so he could hold my hand.

When I noticed it was after midnight he:

A) Called me *Pumpkin*. Told me to come back to his. It was closer than where I lived.
B) Turned the key in the ignition. Drove me home like he promised my parents.
C) Offered to call me a cab.

When it was agreed I'd go back to his he:

A) Promised not to touch me.
B) Said I could borrow one of his shirts to sleep in.
C) Let me pat his spaniel who had waited silk-eared for him by the front door.
D) All of the above.

As I was falling to sleep I:

A) Felt his hands creeping up the borrowed shirt.
B) Smiled at his heavy breathing. Proof that a man could keep his word.

When I realized what was happening I:

A) Told him to stop.
B) Didn't need to tell him anything, he was asleep.

C) Wondered why he had lied to me.

D) Wondered why I always swallowed the words I wasn't supposed to, like chewing gum.

When I asked him to stop he:

A) Stopped at once.

B) Stopped the second time I asked.

C) Pretended not to hear me.

When he stopped I was:

A) Grateful.

B) Already on the phone lodging a complaint with his mother.

C) Trying to ignore the heat in my ears. Guilt? Shame? Disappointment (in myself)?

For the rest of the night I:

A) Didn't sleep.

B) Slept with both eyes open.

C) Slept soundly.

When it was time for the first train I:

A) Crept out of the room without waking him.

B) Kissed him goodbye as if to thank him for not raping me.

C) Partnered with Taylor Swift to write a song about him.

A week later I found out he had:

A) Run away to a Tibetan monastery to learn the sacred art of meaning what you say.

B) Told all of his friends he'd fucked me anyway.

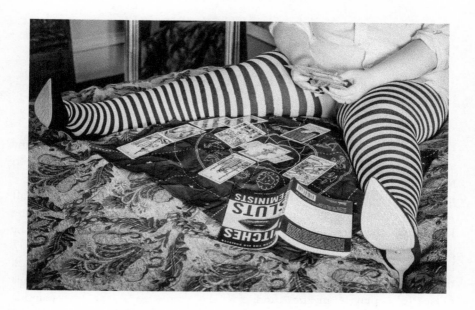

WHAT FALLEN WOMEN WANT

I want / to make / an exhibition / of myself / at The Royal Academy
a fruit / bowl filled with / anorexic / apple cores clenched / between
my thighs / critics will / note I've discovered / how far / I can sink /
my teeth into flesh / until there is nothing / but the / bare / truth / left
/ I want / to conduct / a séance / summon the spectre / of Christina
Rossetti so she can pen / a poem / about how I can't / be saved / by
golden charity / how Australia isn't far enough / away / to drown / my /
bald depravity / I want / to plant / a black / iris / in the soil
that birthed / Adam and Lilith / Grow / a shrine / to Georgia
O'Keeffe / pray / in the afterlife / she confessed / she was painting
/\ cunts /\ which she torture-tickled with her bristles / for months I
want to beckon / the world's disapproval / raise / Insta-worthy
eyebrows in the street / about how my grey-bearded boyfriend
is too old / for me / how I must / need / #therapy / I want him / to
bend / me / over / photograph my plus-size / ass / show every stranger
/ we meet / planetary cheeks / made ripe / by the strike of his hands /
I want to ride / topless / on the back / of his motorcycle / engine
growling / hard against my clit / I smile / wave / with all the practiced
/ modesty / of Jackie O / at slack-jawed tourists driving / motor homes
as they stare / at my tits bouncing / by on Route 6 6 6 / I want to guzzle
/ shame / straight / from the bottle / like crisp Bollinger / to kneel /
on all fours beg / to be fucked / from behind / like a she-wolf I want
/ the moon / to howl back / at me / when I cum / I want to browse an
/ adult video / store / sporting a miniskirt / no underwear / debate /
the subtle / undertones of Dante's Inferno / with my fellow sickos /
strut / out / clutching a sex / tape filmed in the Public Orgies aisle / oh
/ and baby / I'm / the star / I want to want / nakedly / without choking
/ on godforsaken pips / To suggest a drunken fuck / down a darkened
alley / without / someone changing / the subject I want / to feel / for
one orgasmic / blink / I haven't been neutered / at the fledgling / age
/ of forty

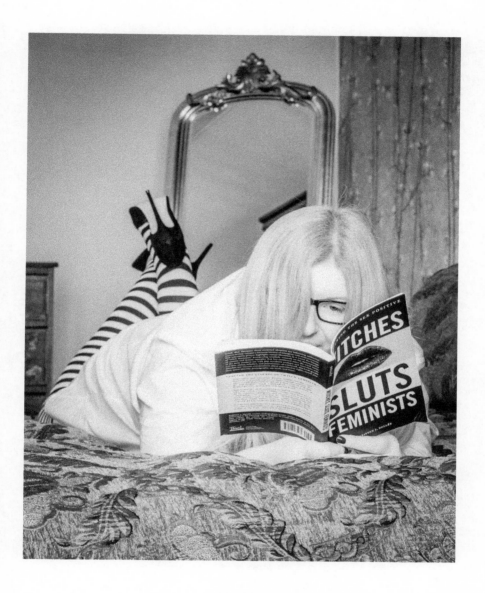

SHRÖDINGER'S KISS

He will.
He won't.

A Peaceful Neighbourhood

Peggy told me that she started taking Valium.
When Teddy takes her to bed she can't bear to leave the lights on.
Afterwards silence roars like a Soviet bomb.
It's so loud he's going to leave her for Vietnam.

Darling, it's our duty to never get that numb;
together, we'll create our own brand of suburban –
the kind they'd never advertise in *Woman's Home Companion*.
Peggy told me that she started taking Valium.

Let me greet you at the door wearing nothing but my apron
spank me with the wooden spoon in our space-age kitchen
till I confess I skipped my finishing school class on diction.
When Teddy takes her to bed she can't bear to leave the lights on.

But we, we'll screw in every possible position:
keep the curtains drawn and leave the windows open
so the neighbours can hear us while they're pruning their geraniums.
Afterwards silence roars like a Soviet bomb.

Underneath your work suit, you'll wear my nylons
a secret, silky thrill, longer lasting than uranium.
I'll never let you die from all that thunderous tedium.
It's so loud he's going to leave her for Vietnam.

I AM THE INVISIBLE WOMAN

I turned forty yesterday.
Became a wraith the naked
eye can't follow.
Like Andromeda's Halo,
only those with ultraviolet vision
or access to Hubble
can see me now:
auditioning to be
a presenter on MTV.
Burning my unwashed laundry
on a funeral pyre.
Taking a pregnancy test
just for the mock-suspense.
Wearing thigh-high boots
while shopping for eggplants.
Modelling for the cover
of Teen Vogue. Caption:
if you're lucky,
you'll live long enough
to look this old.
Fuck your acid peels!
I'll stay young
by begging for a lollipop
after hydrocortisone injections
at the doctors. I will push
every button on the elevator

at once. I will destroy
the black hole
middle-aged women
are warned will swallow them up
in all the ads for incontinence pads.
I will defy its gravity.
Bell jar for a helmet,
jetpack with a fuel tank
full of Vagisil,
I will fly to the stars.
Cement it shut
with expired
anti-wrinkle cream
inherited from my mother.

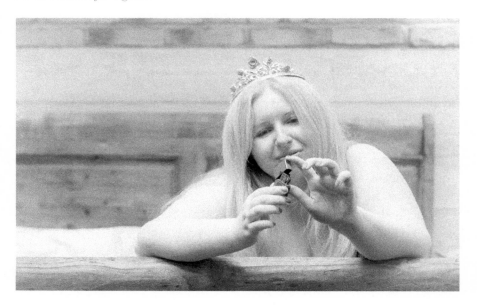

I guess it's fun
to let you believe
you're the dangerous one.

APOLLO USED TO CHAT ME UP EVERY FRIDAY NIGHT AT YALE

because he was lazier than a python in the midday
African sun. When he saw me order the large fries
to maintain the moon-curves of my thighs he told
himself I was a sure bet. He never guessed his pretty
face would hold no weight with me. That I could smell
the cruelty on his breath, more acrid than twenty-cent
vodka shots, always on *special offer*. I had foreseen tomorrow,
when he'd joke to his friends that he had been down on his luck
enough to fuck a *fat* girl. Laugh about how grateful I had
looked as he pushed inside me. How quickly I came. How wildly
I moaned. A myth he would spin to cover up his own
premature ejaculation. I knew I would wake the next day
to his fly rasping out its cowardly goodbye as he slithered
away, without so much as a civil handshake. So, no matter
which ornate mask Apollo wore, I'd go home to my vibrator
Spread my legs. Fantasize about bearded Hephaestus instead.
Dream of a post-coital awakening with him when, after
centuries of volcanic sex, he would fetch a bulging
Saturday paper. And I'd love his big, blunt forehead
the way his mother never had. While he spent his
immortality feeding me breakfast pastries in bed.

I NEVER GOT A MERIT BADGE FOR SEWING

just for my live striptease readings on Onlyfans of poetry by Sylvia Plath.

for fucking a married man on the sex o clock news.

for lending a trans woman my lipstick. Blowing her a kiss.

for smuggling neon dildos into the local nunnery.

for sporting a straightjacket in Paris. Until they were deemed the new must-have accessory.

for penning my thesis on alternate endings for the hit TV show Gilmore Girls

[SPOILER ALERT! in every one of them Rory ends up with Jess].

for curating a museum of my dissected, frog-like regrets. not one prince among them.

every night, after spurning my prayers, I polish each sparkling achievement

contemplate the comments I'd generate if I posted the details to Mumsnet:

You are a hornet in a bonnet, tied with a ribbon of burnt orange (so last season).

You are the Patriarchy's footstool. Burn your push-up bra, quick, bitch!

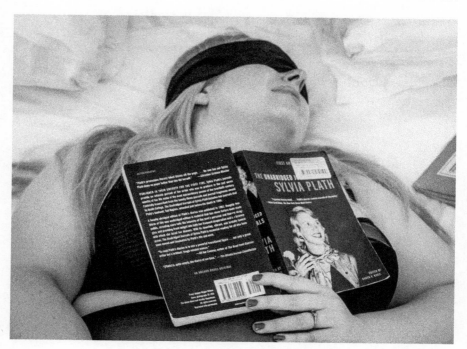

You are an unsolicited promotional leaflet for a milkless breast.

oh, how I would wear their insults as red rosettes.

like a thoroughbred who refused to enter the cage, yet somehow won the race.

THE WORLD LOOKS SMALL FROM HERE

Let them whisper that you're too old for me;
that I'm just a supple mid-life crisis.
They don't know how long you've thirsted
to taste the ocean between my thighs
or how unapologetically we fill each other's negative space.
They don't know that I fetishize your hands:
two firm miracles, the hands of Eros sculpting me
into an intrepid comet, hurtling
through your obscene darkness. They don't know
how tenderly you reached inside my chest
when we first met, pulling out a mottled blue
song thrush egg. Or how many eons you waited for my heart
to peck

 peck

 peck its way out, hatching
the indecently virtuous woman who featured in all the centrefolds
you hid from your wife. They don't know you have the stamina to fly
me to Jupiter but instead taught me to spread my own wings so I could soar
on my terms.

So lover, let them whisper.
I promise we'll never hear them from this high up.

You are a wild boy.
You smell like campfire smoke.
You taste of huckleberry,
& your hands are rougher
than tree bark.

He's the good bad boy
I've always dreamed of.

FIELD NOTES: HOW TO STAY ALIVE IN CALIFORNIA

I

Pushing my last quarter into a pay phone on Sunset Boulevard
between North Kings Road & Queens, I dialled, held my breath
in the rain until I heard a click, & his tongue rolled over my name.
His voice was gruff & soft, like the sands of Santa Monica beach,
& the grey wolves that once roamed there before they were eradicated in 1924.
A voice with fangs & softest fur, caught between a growl & a purr.
He was the only one I wanted to call, in August 1989. Just to say,
I was leaving Hollywood for good because LA didn't love me anymore.

It was gone three am but he was still wide awake. He was nocturnal,
& had once mentioned, casually, that he hadn't slept since he was six.
& I often wondered if he would if *I* kissed dreams upon his eyelids.
He told me to wait at the Hard Ride, a biker bar a little way up the strip.
He'd fire up his 1974 Harley & meet me there, his single headlamp
a lighthouse in the jasmine sea of my darkest night.

II

I watched him push quarters into the Wurlitzer, breathed in the scent
of nicotine & leather. He turned to me eyes calm blue like the Pacific
mine, stop-light red from crying & lying awake, knowing I must spread
the wings I'd sewn of feathers, plucked from sirens on adventures
I could tell nobody about. Yet petrified of drowning in my Icarian lust,
my desire to touch not just the Sun but all the exoplanets the scientists
hadn't yet named. Terrified, that if I didn't find some peace, the beast
at the centre of my own labyrinth would never sleep.

What made me pine to hold hands with Pandora and Eve, pinky
swearing to leave no box unopened? No apple unbitten. To touch
tongues with Lilith while the boys called us she-devils for refusing
to lie mute like corpses as they fucked us. He sat opposite me
in the booth, grey hair damp with rain. Took my hands in his
& said the words no other man ever had: *I'm listening.*

III

At first, I wanted to kill myself. At seventeen, I realized I was a monster.
I tried to wash the devil away with an ocean of antiseptic vodka. When that didn't work,
I made an appointment to have the demon surgically removed
but the doctor took one look and said he couldn't cut it out of me. It was as vital
as my heart; without it I would die. Since I wasn't ill-disposed
towards Death, in fact we'd been flirting for a while, I left & hiked
to the Hollywood Sign. Climbed fifty feet to the top of the H, stretched
one silver-slippered foot over the edge, waiting for momentum to seduce me.

But even gravity had a hotter date that night. Teetering on the edge
of sickening cliché, I imagined a stranger in a downtown diner, reading
about how I dived spectacularly into my own private oblivion. & in my mind,
I saw them shrug. Because an artist succumbing to the torture
of pouring colour into this world was no longer startling (perhaps it never was). &
I wanted to be startling. Even more than I wanted to die. So

<div align="right">

I
climbed
down.

</div>

IV

ZZ Top played on the juke box. A song my bearded biker blended
into a mixtape for me years before. We should have admitted then
that we wanted to be more than friends. You only share music with those
you've already tied your heart strings to, like a child tying thread to a kite
in the hope that, one day, it might kiss Neptune. But when we met,
he was already somebody else's baby. & I was engaged
to a billionaire with a penthouse apartment and a private jet.
And my husband couldn't murder the monster

caged behind my ribs as I'd prayed he would. Poor darling,
he flinched too much. What a fool I was to believe
Grace Kelly & I could drink at the same civilized tea parties.
The canyon ladies had cookie-dough hearts, mixed for the charity bake sale.
Mine had a reptilian tail that swatted all the boys away. Oh, how urgently
they ran! Bullet-quick. Back to their vanilla-scented prom queens.

V

I'm in love with you, I blurted out. *Always have been. Even before we met, I knew you were alive, somewhere, in this practical joke of a universe. I saw you in a premonition, fucking someone else. You wondered why you burned to be back on your Harley the second you climaxed. I knew the answer: you weren't fucking me. I pined for you: star-spangled shadow, stranger who didn't belong to me, as violently as wild morning glory pines for the sun. I craved your golden kisses. White petals parted. Yellow-bellied centre on display. But the moment you were in reach I whipped my hand away. Because everything I touch turns to silver. I was always a runner up. To his career; the kids from his first marriage; his ego. I never could glitter like I wanted to, for you.*

I waited for him to stand. Make his excuses. To explain there were no roles
in Hollywood for women with crooked teeth. That if I felt second-rate
I was probably uninspiring, like Casablanca. Anyone who holidayed in Morocco
knew it was a bore without Ingrid Bergman. I waited for him to say the sooner
I flew back to England, the better. But he remained quiet, immovable
like the San Gabriel Mountains. A wise smile cut through his rugged face.

VI

In the parking lot, he pressed me hard against his Harley, his body leaning into mine. The orange promise of daybreak filled the Californian sky & he whispered: *'What if you're not a monster?' What if you're just human & those Stepford Wives take daily Valium so they don't notice all they sacrificed for a microwave oven? What if the real monsters are those who dictate what you can & cannot want? What if the only way to truly die is to ignore the voice inside telling you Hollywood sunsets were just a lie a conman sold you so you'd buy diet pills? That your desire to get down on your knees and suck cock cannot be measured on a six-point scale?*

You are Kandinsky's great-granddaughter, not designed to be confined by boundary lines. You are your own work of art. I didn't respond. I simply looked into his tidal eyes long enough to accept that, in life, there are no closing credits. No a*nd they lived happily ever after.* Just limitless carnelian horizons to ride towards, he in the king seat, me in the queen. His smile framed in the side mirror. My arms embracing him, & the uncontainable truth that the only certainty is how deeply we love in each transitory moment.

Clothed, he is a riddle.
Shirtless, he is a poem.
Nude, he is a love letter
to the gods.

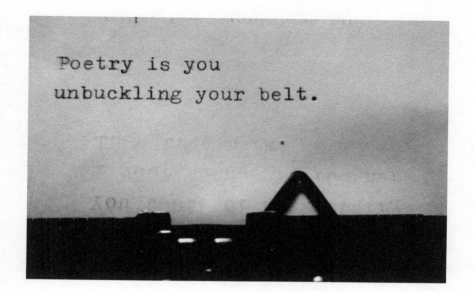

ODE TO YOUR BELT BUCKLE

The gentle jingle as you unhook your belt
is more rousing than my wedding bells.
Stretched between your fists
the black leather line
Good Feminists told me never to cross.
You brandish it with the same zeal
prehistoric man held charcoal and iron oxides.
Aching to make your mark.
My ass your canvas,
where you'll graffiti
We were here! We were alive!
in red ochre.

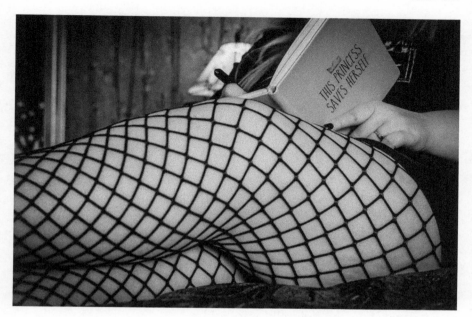

IT'S SUNRISE IN NEW ORLEANS

I

In our pocket-sized holiday apartment on Bourbon Street
you fasten the red lace bra you ripped off me last night,
while the neon lights below burned orange and electric blue.
Now dawn spins the sidewalks into gold,
you kneel at my feet, as though I were Erzuile herself,
pull silk panties over my reddened cheeks,
glide sheer stockings back up my thighs,
buckle my nude, patent court shoes.
Thank you, half-beast, I whisper, as I stroke your soft, grey fur
and a distant horn blares on a non-stop freight train
hurtling through Union Station. All my ex-boyfriends are on board.
Stowing away in wooden crates once filled with tobacco and sugar cane.
Stealing out of the city at first light, and arguing
over which of them unbuttoned my blouse the fastest.

II

I button your shirt, slowly, while the sun kisses the Mississippi River.
Missing the beastly fleece on your chest the moment it is eclipsed
by white, civilized cotton, I fasten your silver cufflinks:
the left sleeve engraved with the King of Hearts,
the right carved with the Queen.
The weather-beaten steel in your bones binds the two,
like the Crescent City Connection -
the last bridge between here and the Gulf of Mexico.
Straightening your collar, I look deep into your eyes of Atlantic blue.
Somewhere, out there in a marginal sea, there is an island not-quite-forgotten.
All the natives are shipwrecked girls fool enough to have let you go.
They laze beneath palm trees, pulping purple seagrapes into wine
while boasting about how easy it is to crush a heart
with their bare hands.

III

We step out for pancakes and chicory coffee at a little café in Jackson Square.
The towers of St Louis Cathedral reach for the same stars you have lifted me to
every night I've slept in your arms. A guide passes with a walking tour, explaining
that this park was once the heart of colonial New Orleans. That voodoo priestess,
Marie Laveau is buried in the cemetery, though she was seen once or twice in town,
sipping milk punch, long after her death. And an apparition of a holy man
who once led worship here, appears at Midnight Mass each year.
It seems no heart is without a ghost or two.
The same thought flickers across your wry smile
as you weave your fingers through mine, and squeeze.
I look down at my little hand in your giant paw
that knows just how to maul me in all the ways I like best, and yet
understands the tenderness of zipping up his beauty's dress each Midas morning
ever after, in dreamy Louisiana where the virgin white magnolias grow wild.

Never bring a bra
to a water fight.

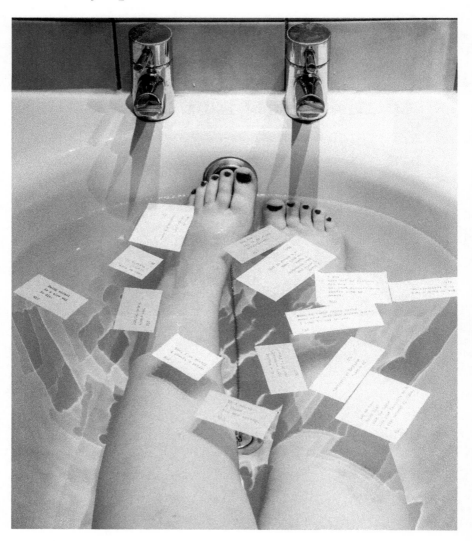

BEYOND THE
CITY LIMITS

Let's fuck like a record sung by Lana Del Rey
I'll get down on my knees and all the Feminists will say:
a woman cannot find empowerment that way.

I'll be your knee-socked little girl and teach you how to play
my leather-belted Daddy who makes the rules I'll disobey;
let's fuck like a record sung by Lana Del Rey:

gag me with a ballot on election day
walk me through the Senate with my breasts on full display;
a woman cannot find empowerment that way.

While I'm kissing the stars where your flag's begun to fray
call my mother and convince her that *you* led me astray. Then, Sir:
let's fuck like a record sung by Lana Del Rey.

Bend me over the hood of your scarlet Chevrolet
part my thighs like the shores of Monroe Bay, even though
a woman cannot find empowerment that way

we'll give those grey commuters their own X-rated matinée
and on the way back home they'll buy their wives new lingerie.
Let's fuck like a record sung by Lana Del Rey; because, baby, I'm proof
a woman can find empowerment that way.

MY POETRY IS MY LEGACY

I

which everybody thinks is about me.
Actually, it centres around my quadruplet sisters
who live in neighbouring solar systems.
One had a kid and became a stay-at-home mum.
One transitioned into a man –
we all love how sensitive he is
on intergalactic video calls.
One qualified as a plastic surgeon,
specialising in boob jobs.
I became a sexually submissive woman.
We have all been labelled a threat to feminism.

II

My legacy is a statue in my hometown.
A sculpture of my Weightwatchers area leader.
I once confessed I had eaten a doughnut for breakfast.
Her face filled with such rage,
that with one wave of a breadstick
I'd smuggled into the meeting,
I transformed her into granite.
Her stony expression, a memorial to the thin girl
I might have been if only she'd shown some compassion.

III

My legacy is the lipstick marks I left along his cock.
Though he has long since washed them off
Braunstein and Pati (2007) assure us no data is lost
in this universe.
Somewhere, there is a black hole
surrounded by a red giant mouth screaming:
more
more
more.

IV

My legacy is my cellulite.
I've been contacted by the military
about forging armour from its fibres.
It will survive any exfoliating coffee scrub.
Blasts from the heaviest caliber bullets.
After the nuclear holocaust, survivors
will carve it into blocks, rebuild.

V

My legacy is the white rose tree
I will plant
in a garden on the outskirts of Paris.
From my deathbed,
I will look out of the window
watch white petals snowing
across the Eiffel Tower.
I will smile knowing
I lived *the unforgettable.*

Acknowledgements

Heartfelt thanks to the tutors who have guided me while writing this collection: Rachel Long, Kim Moore, Rowan McCabe, Clare Shaw, Julie Irigaray, Jo Flynn, Helen Eastman and Leah Umansky.

Gratitude also goes to my editors: David Brookes and Ella Frears for supporting me through the line-editing process.

A huge thank you to Andrew Douglas who has been the best creative partner a gal could hope for.

And, as ever, respect and appreciation goes to my husband Jo for his positivity about my wild and weird little project.